T0158246

LIKE A GHOST I LEAVE YOU

Like A Ghost I leave You

———

Quotes by Edvard Munch

© 2017 MUNCH, Oslo

All the quotes are taken from Munchmuseet's digital
archive of Edvard Munch texts: www.emunch.no
Text about e-Munch (p.161–163): Hilde Bøe
Translation from Norwegian: Francesca M. Nichols
Editorial Assistant: Karen E. Lerheim
Head of Publications: Marius Aronsen
Design and layout: deTuria Design
Published by the Munchmuseet
Typeset in: Minion 11,5/16
Paper: Arctic Matt 130 g
Print: RKGrafisk, Oslo

ISBN: 978-82-93560-08-1

MUNCH thanks its sponsors and supporters

CONTENTS

———

ART AND NATURE 9

FRIENDS AND FOES 37

NORWAY 51

HEALTH 67

MUNCH ON HIMSELF 79

LOVE 89

VIGELAND AND OTHER ARTISTS 113

WORLDVIEWS 127

MONEY 139

DEATH 149

———

EDVARD MUNCH 158

MUNCH'S TEXTS 161

WORKS OF ART AND PHOTOGRAPHS 164

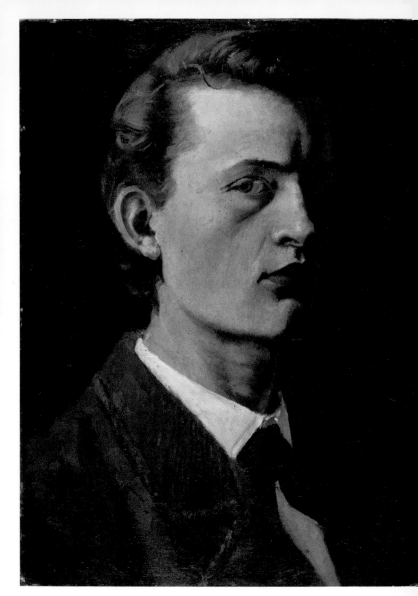

When I look through my writings
I find much that is naïve – and there
are also laments about my unkind fate
which do not seem manly

SKETCHBOOK 1909–11

ART AND NATURE

———

Art began as ornamental art
they say –
That's a lie –
One recounted one's story –
one confessed one's faith in God in
stone and on the surfaces of walls

UNDATED NOTE

The religion of time – that is,
the soul of time
must be reflected –
There must not only be ornamental art
This word has ruined very much

UNDATED NOTE

There is incessant talk about ornamental art
Art has from its beginning been
ornamental – they say
That's like saying poetry
is entertainment literature

NOTE 1930–40

In my art I have sought to explain
to myself life and its meaning –
I have also intended to help others to
understand their own lives

NOTE 1930–34

Speech was created to deceive confuse
and betray Humans – Poetry and Verse
are the Concave Mirror of the Paradox,
created to capture and reflect
a glimpse of the Truth

Undated note in a copy of Emile Zola's *Nana*

It is better to paint a good incomplete picture
than a poor completed one –
Many believe a picture is completed when they
have depicted as many Details as possible

A line can be a completed work of art

What one paints must be done purposefully
and with feeling – There's no use in executing it
in a way that adds insensitive and
indifferent things

Sketchbook 1927–34

My art is a confession – Through it I seek to
clarify to myself my relationship to the world
In other words a form of egoism –
Though I have always simultaneously thought
and felt that my art might also clarify [matters]
to others in their pursuit of the truth

SKETCHBOOK 1927–34

A chair may be of as much interest as
a human being
But the chair must be seen by a human
It must in some way or other have moved him
and one must cause the viewers to be
moved in the same fashion
It is not the chair that is to be painted but
how a person has experienced it

SKETCHBOOK 1889–90

I am reluctant to write about my art
It easily becomes a programme
All Programmes are destined to be abandoned
– just like all associations and alliances
– They hang about one's legs like heavy chains

NOTE 1928–30

A good picture with 10 holes is better
than 10 poor paintings without holes
A good picture with a poor primer is better
than 10 poor pictures with good primers

NOTE 1928–30

A good picture never disappears
A brilliant thought does not die
A charcoal line on a brick wall can be
more valuable art than many a large
picture in costly frames

NOTE 1928–30

I do not paint
from nature –
I help myself from
its bountiful
platter

I do not paint
what I see
– but what I saw

NOTE 1928

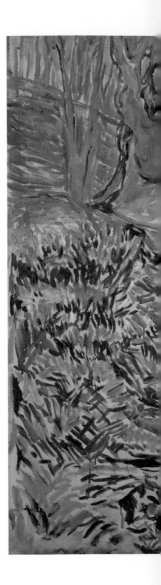

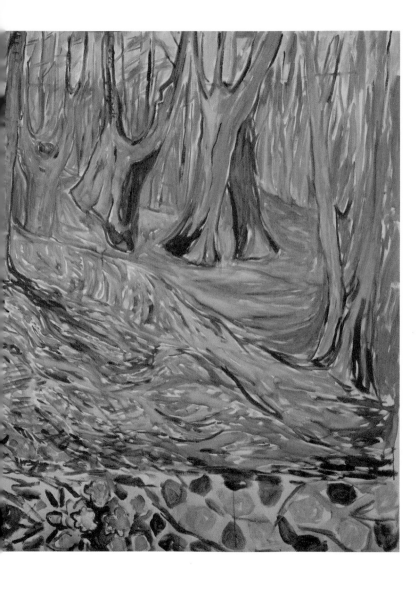

Many painters work so cautiously and
meticulously with the primer – and with the
execution of the picture – in order to preserve it
for eternity – that they lose their flame
And it happens that the painting becomes so
tedious and poor that it ends up in a dark attic

NOTE 1928–30

My art had its roots in these reflections where
I sought an explanation for this disparity in
life – Why was I not like others? Why born[,]
something I had not asked for
This curse and the reflections on it became the
undertone in my art – Its strongest undertone
and without it my art would have been
something else

UNDATED NOTE

Who is this laughable Gentleman Th. in
Dagbladet – This Gentleman believes I am ill –
An Artwork is not ill because one depicts Illness
– or Hate – or Love – Poor Art is ill – I think
for instance that Gude's Art was sometimes ill –
and – often Werenskiold's

Undated draft of a letter to Jappe Nilsen

I work in my studio in the mornings extend
my arm and measure with my pencil the
proportions of the body of the naked model
who stands in the middle of the studio.
How many heads fit into the body
how wide is the chest in relation to the length
of the body. It bores and
tires me – dulls my senses

Sketchbook 1890

We strive for something else than a mere photograph of nature. Nor is the aim to paint pretty pictures to hang on a living room wall.

NOTE 1889

Nature is not only that which is visible to the eye – it is also the inner images of the soul – images on the back side of the eye

NOTE, WARNEMÜNDE 1907–08

Art is the opposite of nature.
A work of art simply comes from the inner soul
of a human being.

– Art is the picture's form materialised through
human nerves – heart – brain – eye.

– Art is the human craving for crystallisation.

Nature is the infinite realm from which art
takes its nourishment.

NOTE, WARNEMÜNDE 1907–08

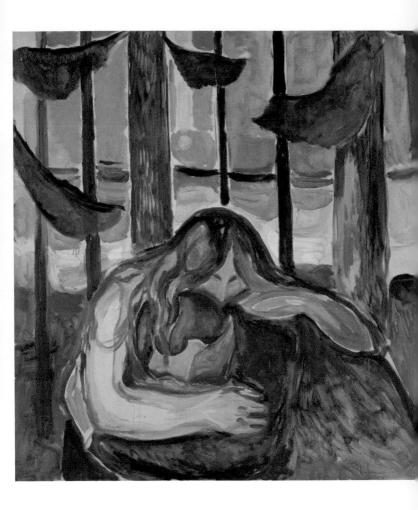

One shall no longer paint interiors,
people reading and women knitting
They will be people who are alive,
who breathe and feel, suffer and love –
I shall paint a number of such pictures
People will understand the sanctity of
it and they will take off their hats
as in a church

Note 1929

It was during the time of Realism
and Impressionism –
It happened that I in an agitated sickly
state of mind – or in a joyful mood found
a landscape that I wanted to paint –
I brought my easel
set it up and painted
the picture from nature –
It was a good picture –
but not the one I wished to paint –
I did not capture what I saw in the agitated
sickly mood or
in the joyful mood –
– This occurred often –
on a similar occasion I began
to scrape away what I had painted –
I searched my memory for the
first picture – the first impression –
seeking to retrieve it

Note 1928–29

A work of art is a crystal – as
the crystal has soul and will
so must the work of art have it –
It is not enough that the work of art has
the correct exterior planes and lines

NOTE, EKELY 1929

Naturalism was one worldview
– Symbolism and Expressionism another –
Pointilism, linear art and Art Nouveau and
finally Cubism have been necessary
technical exercises in style

NOTE 1934

The camera cannot compete with the brush and palette – as long as it cannot be used in heaven or hell.

NOTE 1890

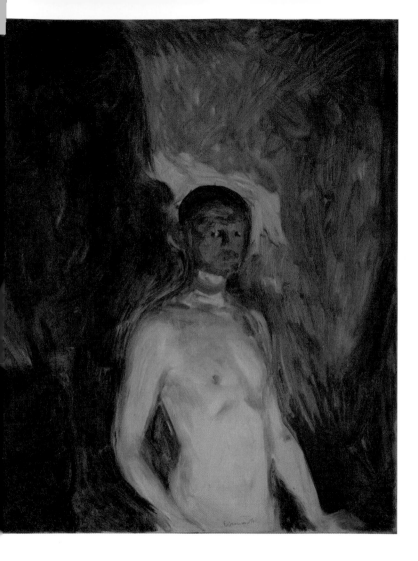

Art comes from one human being's compulsion
to communicate to another – All means are
equally appropriate

NOTE 1890–92

In Painting as in literature one often
confuses the means with the goal
– Nature is the means not the goal –
If one can achieve something by
changing nature – then one must do so

NOTE 1890–92

A Country's Artists – Poets – are sensitive
Phonographic devices – they have been given
the great and painful Ability of absorbing the
Impulses – that Society gives off –
The Poets give these back
in a condensed Extract
– If an Artist is driven from his Country
– the Country simultaneously drives away –
a fully charged Electrical force

NOTE 1907–08

To explain a picture is impossible
– It is precisely because one cannot explain it in
any other way than it has been painted –
One can only give a little hint of what one
was aiming at

NOTE 1890–92

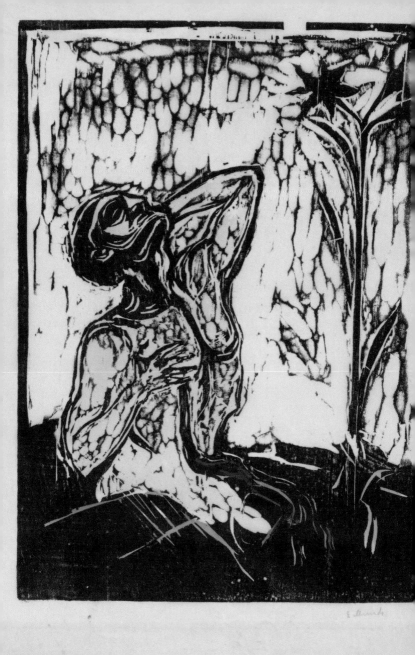

E Munch

I do not believe in art which has
not been forced into being by man's
compulsion to open his heart
All art – literature as well as music
must be created with one's lifeblood –
Art is one's lifeblood

Note 1890–92

The fact is that one sees with different eyes
at different times. One sees differently in the
Morning than in the evening.
The way one sees is also dependent
upon one's state of mind
This is why a motif can be seen in so many ways
and this is what makes art interesting

SKETCHBOOK 1889–90

When it so happens that last year
and this year I have painted a
large Beach Scene of bathing Men
it seems even that is a suspicious Motif –
I have been so naïve that I thought it was only
dangerous to paint Women

DRAFT OF A LETTER TO HARALD NØRREGAARD,
STOCKHOLM 1909

In an intense state of mind a landscape
will make a certain impression on one
– by depicting this landscape
one will arrive at an image of
one's own mood – it is this mood
that is the main thing
– Nature is merely the means

NOTE 1890–92

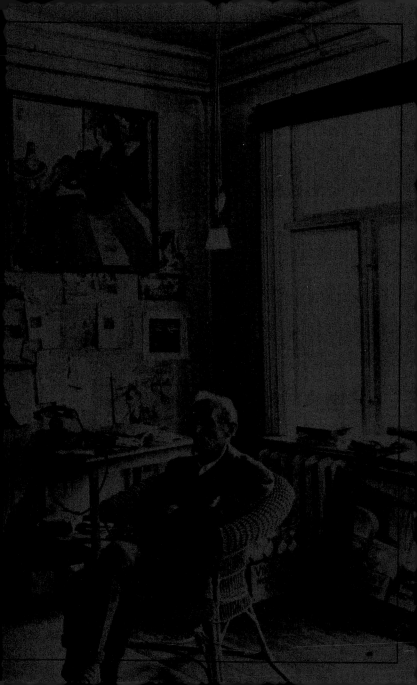

FRIENDS
AND FOES

———

Yesterday there was a meeting of
100 painters who wish to support the
committee – nevertheless it is thought
that they will be a minority
– and then the exhibition will be closed
– This incidently is the best thing
that can happen
one couldn't ask for better publicity

LETTER TO KAREN BJØLSTAD, BERLIN 1892

What do the Norwegian papers say – do they
take in only the poor reviews? let me know –
Here there have also been plenty
of admiring reviews –
All this hullabaloo has been
very amusing.

Letter to Karen Bjølstad, Berlin 1892

It is a Lady!
That is to say – A Lady has the Right to scheme
against – slander – persecute a Man – destroy
a Man through Lies – and Traps – by all the
Means that are available to a cunning vengeful
Person in order to kill a Man
– A Man must remain silent and bear it –
Because it is a Lady

Sketchbook 1908

Furthermore I would almost say that I am
practically homeless and hounded due to
people's unbelievable brazenness and lack of
consideration – I have been forced to move
from place to place in order to find some peace
– The constant threat of taxation of my Studio
pictures caused me to lose the desire
and courage to work

Undated note

I have thought of renting a House on the Coast
in the Vicinity of Kragerø – I must have an open
view of the Ocean and the Forest –
– If only my Enemies allow me the Tranquillity
to regain the Health that they have
ruined for me, that is

Letter to Harald Nørregaard, 1909

Then in the ensuing Years Assault after
Assault – and when I was assaulted an Echo of
Curses in the Norwegian Newspapers –
– I couldn't cope with these
Assaults from Behind –
I had concentrated all my Strength in
defying the Enemy of my Art –
Here is the Tactic:
A Blow from behind
and below the Legs

NOTE 1908

One does not die one is murdered by
one's fellow human beings –
It is with the poisonous gas of words – evil
thoughts – which in radio waves strike
one's vulnerable spot

SKETCHBOOK DATED 1927–34

Architect Poulsen approached me recently –
You seem to have many friends he said –
Yes I said but they are spread about
at a great distance
My enemies are close upon my life –
I am in a snake pit out here – The swine would
grunt if they knew how the boar suffered

SKETCHBOOK 1927–34

Dear Friend! – Yes You are Right – if only I
could retain some Peace of mind I would be
better able to punish my Foes

LETTER TO LUDVIG RAVENSBERG, 1909

And I am ready for the defence and equipped
for the assault – Any second now my birds
of thought will soar
for you were so certain of a victory –
You amphibians and sneak assassins

NOTE 1934

– I lie here pondering a new Attack on
Denmark's Capital – From various Corners of
Germany my Troops arrive here exhausted after
Battle – but after a Period of Rest an Invasion of
Copenhagen's Harbour[1] can be carried out –
– The Norwegians on the other hand shall not
come within Shooting Range

UNDATED DRAFT OF A LETTER TO STEN DREWSEN

Those were troubled days for me back then in
Norway – yet my working spirit was not broken
There have been difficult days here
at Skøien as well
Now they have used poisonous gas and
have succeeded terribly in breaking my
working spirit

DRAFT OF A LETTER TO JENS THIIS, 1939

1 Reference to the Battle of Copenhagen
(Angrepet på Køpenhavns red) of 2 April 1801.

Let me tell You said Ibsen –
It will happen with You as with me –
The more Enemies You gain
the more friends You will have

Undated note

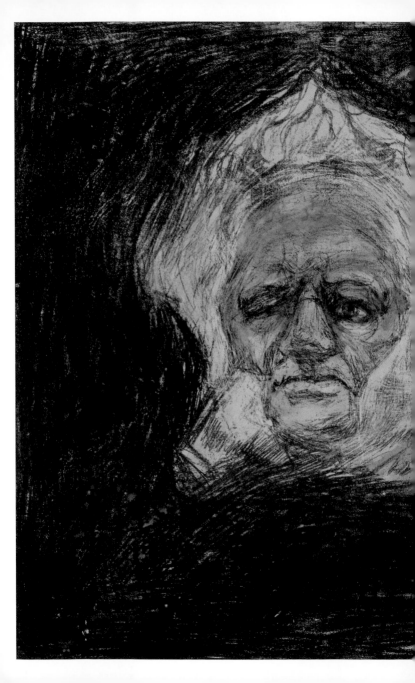

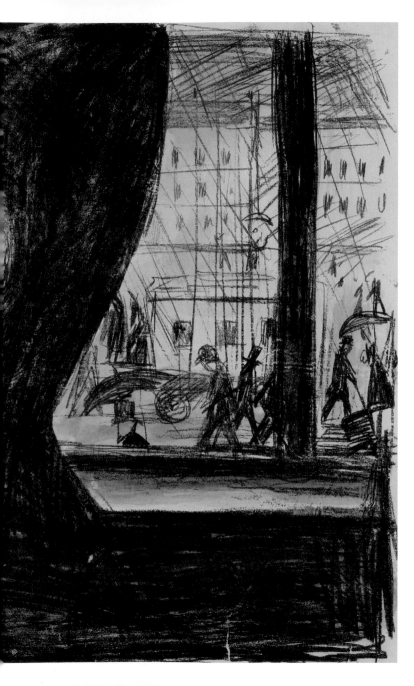

Friends are disguised Enemies
– They sneak into one's House
Consume Your Food, drink Your Wine –
They put Poison in Yours and stab You
in the Back

SKETCHBOOK 1903–04

At that time in Aasgaardstrand a campaign
of lies was directed against me
An act of revenge because I was
unrestrained towards a lady
Out here I have had to suffer a
vindictive campaign of lies because I had a
well-known vicious mongrel sentenced
to being kept on a leash

DRAFT OF A LETTER TO JENS THIIS, 1939

It is not a Joke or a Persecution complex when
I say to myself and my Friends that I have
everything to fear from certain Quarters
That I have stirred up with my Cane the
cunning Anthill which Krohg and his Circle
have built up will certainly have its Effect

LETTER TO JAPPE NILSSEN, 1909

After 20 Years of Struggle – and Misery, good
Fortune comes at last to my aid in Germany
and an illuminated Gate opens to me – this was
in 1902 – Linde and others are buying my works

NOTE 1908

NORWAY

I am getting regular Commissions so
it is quite different from living on a
Starvation diet in Norway where
one is served Profanities as well –
Profanities on dry Bread

Letter to Karen Bjølstad, Thuringia 1906

I might have served art and my country better
had I continued to live in Paris – since one has
not gained any recognition in this
little fledgling society either for my art or
for me personally –
In larger societies an exceptional person
is better understood

NOTE 1930

Have I not written about what I found in a
notebook from 30 years ago?
"I am like Jonah in the belly af the Whale
I saw that the land was good and
I remained there"
That is how I experienced it myself.
Kragerø was good to me

LETTER TO CHRISTIAN GIERLØFF, 1943

I would not recommend painters to take up
residence in Vestre Aker unless they are of a
private bougeoise sort and work with small
pictures in gold frames

Undated note

In Kristiania it was frightful –
and there was no money in sight –
I am now lying on my back on the grassy slopes
in Aasgaardstrand watching the world go by –
Then people will have to make do with
the art they asked for

Draft of a letter to Vilhelm Krag

The country must choose: – Do They want art
by me – do They want city hall decorations
or is it more important to squeeze a couple
of thousand kroner out of me in taxes? and
thereby completely destroying my working
mood and my ability to work?

Undated note

For 20 Years I held out and suffered all the Turbulence that the new Art provoked until those I thought were my Friends and who claimed to be so stabbed me in the Back.
– I was wounded to the core of my Soul –
when I like the fatally shot Deer rose to my Feet and thrashed in all Directions which you will remember – From that Day forward the Earth in Norway burned under my Feet

DRAFT OF A LETTER TO JAPPE NILSSEN, 1906–09

Had I remained living in Norway I would have ended in grief over a wasted talent – and probably crushed by these types like Sørensen and his kind – The support abroad has allowed me to resist the numerous art groups which have turned up during the course of the past 40 years swearing to be the only right one

NOTE 1930

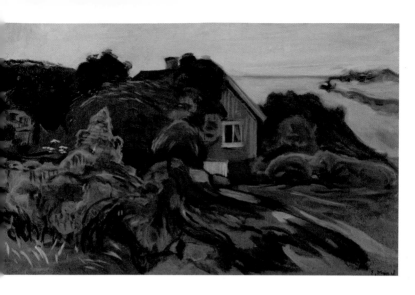

It was strange to be at one's own place
— in one's own House.
No one needed to disturb him — It was
his own Property — It had not cost him
a bundle and it was not grand, but his —
and out there in the Garden were all his
Trees — Stones — Birds —
— the Shore — and the Water that
washed up against the Stones

SKETCHBOOK 1903–08

It is actually very cosy here even in Winter –
although I work much more in Kragerø –
I become so drowsy here

LETTER TO KAREN BJØLSTAD,
HVITSTEN, NEW YEAR 1911–12

I was once tossed ashore in Kragerø
I saw that it was a good place to be and
I remained for 2 or 3 years and longer
In this the nicest of all Norwegian towns – a
perfect haven for sailors who have been at sea
How delightful are these towns
along the coast from Laurvik to Trondhjem –
Inside the fjords they lie shining like
red and white crystals

NOTE 1927–35

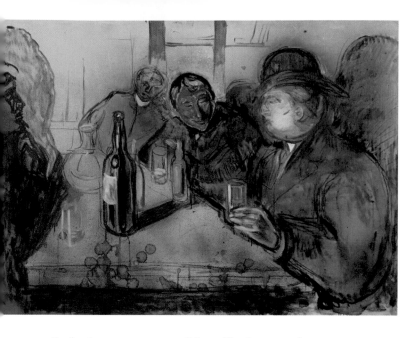

Oslo is not a very friendly haven for
seafarers and wayfarers despite being
Norway's largest seaside town

NOTE 1927–35

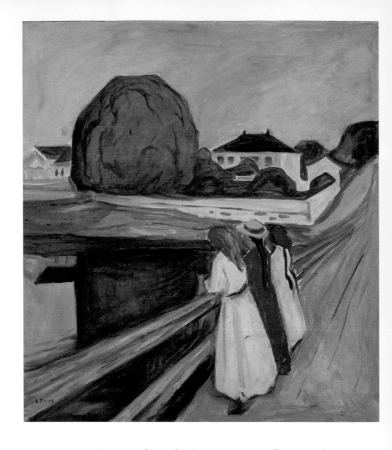

It was lovely in Aasgaardstrand
It is the most beautiful of all the places
along the Oslo fjord

UNDATED LETTER TO INGER MUNCH

It has finally become clear to me that I must
leave this place and find a new domicile – For
the time being I am keeping the place – But will
take up residence in Aasgaardstrand – Perhaps
travel further south – I made a big mistake
coming to Oslo – I am and will remain the
dreaded Painter and Bohemian there in Oslo.
I believe they use me as an example
to scare children

Undated note

I have hardly spoken Norwegian for almost a
Year now – When I see a Norwegian in a Café
here I always have the Feeling that it is an
Enemy – it cannot be helped

Letter to Karen Bjølstad, Thuringia 1906

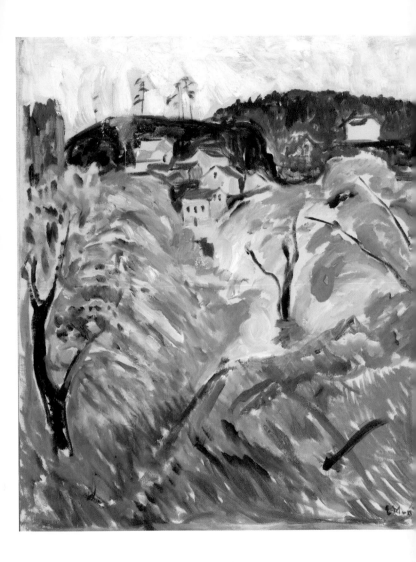

I am staying on the Norwegian Riviera
Aasgaardstrand and Kragerø –
Quite as good as the French one

Undated draft of a letter to Johannes Roede

I have increasingly understood that Ekely
near Oslo is not the place for me – It will be too
strenuous for me to live close to town –
Furthermore I have become very tired of the
place since I have been subjected to all kinds of
harassment by the Authorities of Vestre Aker
and by many of my neighbours –
In the past year I have ceased to show myself
in the street

Undated note

I am up in strange Kristiania again – with its
peculiar Bohemian women – who entice one,
and cause even an old tested gentleman like
myself to dream of eternal love –
It is nonetheless a strange pioneer town this
Kristiania – everything fomenting
– everything seeking its form

Letter to Emanuel Goldstein, 1892

It is disagreeable that I cannot be in
my little idyll in Aasgaardstrand
but when I think of the terrible state of
Agitation that I get into up there I am happy
to be in such a pleasant Place together with so
many Friends albeit in a Foreign Country

Letter to Karen Bjølstad, Weimar 1906

It appears that I will have to remain Abroad
– even though one should preferably paint
in one's own Country – But I only become
agitated when I come home –
I should have perhaps gone away sooner
– After such an atrocious Ambush which my
so-called Friends served me in 1902 I should
have fled the Country – There is nothing more
deadly than setting Traps for People

Letter to Karen Bjølstad, Warnemünde 1907

HEALTH

The Drinks became stronger
the Fits more frequent –
I occasionally also had Bouts of Rage
– Sometimes I got into a Fight with
someone or other

SKETCHBOOK 1908

Yes for me the Pain and Pleasure-mixed Alcohol
Era is a thing of the past – something special
an inscrutable World is closed to me

LETTER TO JAPPE NILSSEN, 1908

Here the Cure is in full Swing – I am electrified,
massaged and bathed daily – The Doctor says
that I lack Electricity and am generally very weak
which is not so unreasonable
The strange thing is that in a physical respect I
have become the healthiest Person on Earth
and tolerate the Cold and Damp
– It would be wonderful one day to be rid of
the tortuous Nervous disorder

LETTER TO KAREN BJØLSTAD, 1908

I am given a daily Bath and must eat as much as
possible in order to cushion the Nerves
with meat

LETTER TO KAREN BJØLSTAD, 1908

As you may already know, since I have
sent Greetings to you[,] I have signed into
a Nerve clinic – I hope to be Rid of the
unbearable inner Turmoil that I have suffered
since that distant Affair –
I should have done it a long Time ago and
spared myself and you and many others
considerable Unpleasantness

LETTER TO KAREN BJØLSTAD, 1908

Two of Mankind's most terrible Enemies were
my Legacy – the Legacies of Consumption and
of Mental Illness – Disease and Insanity and
Death were the black Angels that stood
by my Cradle

UNDATED SKETCHBOOK

A bad Stomach generates bad Thoughts –
A weak Stomach assaults the nervous system
Poor nerves assault the Stomach

SKETCHBOOK 1908

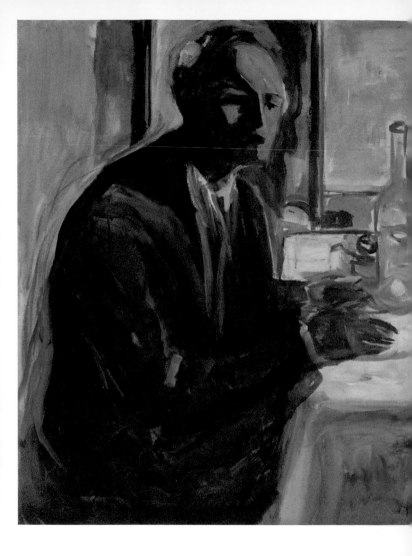

I have entered the Order of "Don't touch anything": Nicotine-free Cigars – Alcohol-free Drinks
Poison-free Women (Neither unmarried nor married)
– So You will indeed find me to be a very boring Uncle

Letter to Sigurd Høst, 1909

I have not yet made concrete Plans with Regard
to the Future – Perhaps I will remain a little
longer in Denmark – Doctor Jacobson has been
very good and given me a strong Cure
I am like an electrified Ramses II

LETTER TO LUDVIG RAVENSBERG, 1908

Yet I often have the feeling that I must have this
existential angst – it is essential to me – and that
I would not want to be without it – I often feel
that even the illness has been essential
– In periods without angst and illness I have
felt like a ship sailing in a strong wind
– but without a rudder – and asked myself
where? where will I run aground?

SKETCHBOOK 1927–34

Thought kills Emotion – and increases
Sensibility – Wine kills Sensibility
and increases Emotion

SKETCHBOOK 1908

Can it be that it is an illness like the others – is it contagious – are there bacteria in the rooms of Monte Carlo – I am completely feverish – I do not recognise myself – I who used to lie in bed for so long – do not sleep more than a few hours at night

Note 1891–92

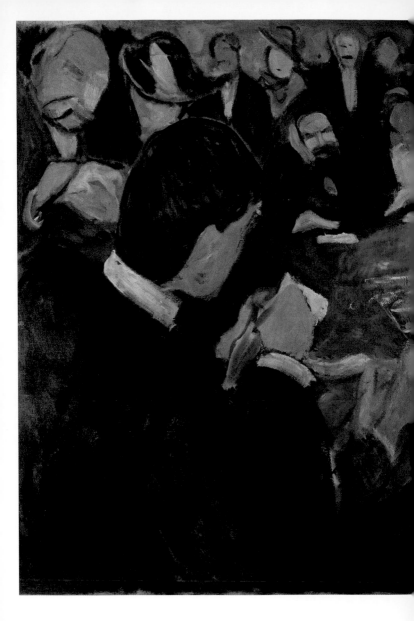

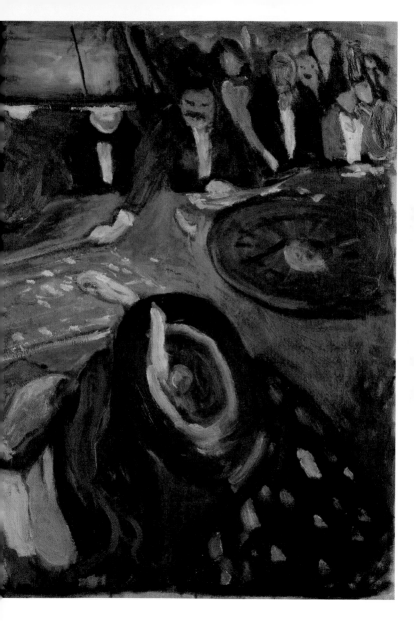

MUNCH
ON HIMSELF

Generally one could say
that I doubt yet never reject
or mock religion

SKETCHBOOK 1909–11

Due to the germs of disease that I have
inherited from my father and mother I had
since my youth decided to go through life
unmarried and I felt it would be a crime for me
to enter into Marriage

NOTE 1933–35

There is a German [fellow] who is going to
produce a book: "Munch and Germany"
There it is all over again
I am not in the mood.
What will be left for my autobiography?

LETTER TO SIGURD HØST, 1934

When I had painted professor Jacobson's
portrait after a month's convalescence I said:
I have been true to the goddess of art
now she is true to me

UNDATED NOTE

In *The Sick Child* I paved new roads for myself –
it was a breakthrough in my art.
– Most of what I have done since had
its genesis in this picture.

Printed text 1928

– Had I been in Possession of the as yet
undiscovered little Remote telephone which one
carries around in one's Pocket You would have
long ago received Communications from me

Undated draft of a letter to Jens Willumsen

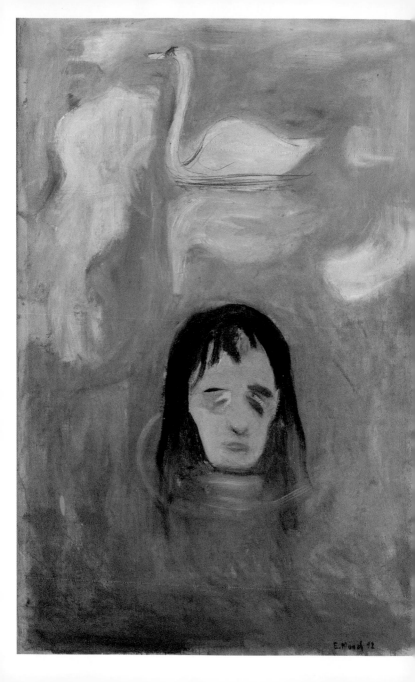

I lay in the depths amidst vermin
and slime – I longed to rise up to the
surface – I raised my head above the
water – and then I saw the swan – its
radiant whiteness – I yearned for its
pure lines

…

I who knew what existed beneath the
shiny surface could not be united with
one who lived among illusions
– on the shiny surface that reflected the
pure colours of the atmosphere

Undated note

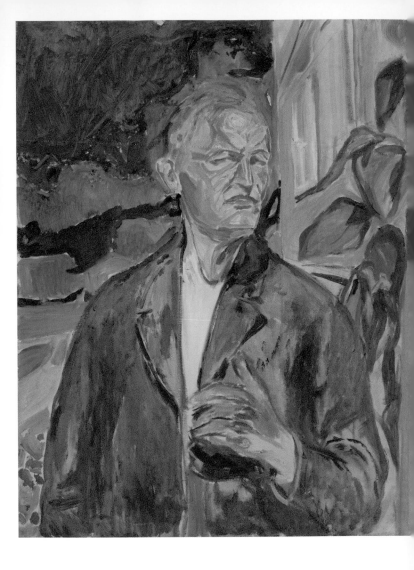

A shooting range was set up right
by my buildlings so that revolvers
hammered all day long

My dogs became crazed by the
shooting so they chewed 4 expensive
rugs to pieces – 24 fruit trees
3 dog houses – When they began to eat
the buildings, I shot them

Undated sketchbook

LOVE

———

During the time that we have been
together – in all of the moments
– when we lay side by side – when we visited
the wonders of Florence – when we walked
together along a sunlit road – when we sat
together – and even in the moments that
should have been the most intensely joyful
– happiness shone on me as though
through a door ajar – a door that separated
my dark cell from life's immense and
dazzling ballroom

DRAFT OF A LETTER TO TULLA LARSEN, 1899

The Kiss –
A warm Rain fell
I held her around the Waist
– she follows slowly –
Two large Eyes facing mine –
a wet Cheek against mine
my Lips sank into hers

SKETCHBOOK 1903–04

The Man and the Woman are attracted to one
another – Love's underground Cable carried its
Power into Their Nerves – The Wires trussed
Their Hearts Together

UNDATED SKETCHBOOK

I have always placed my art before everything
– and I often felt that women were
a hindrance to my work

NOTE 1933–35

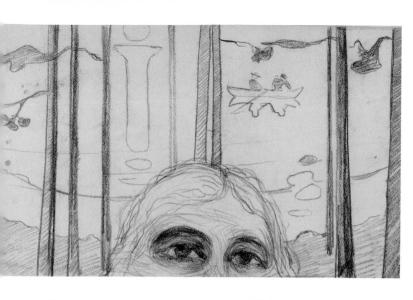

Your eyes are as large as half the sky
when you stand near me and your hair
with gold dust and your mouth
I do not see
– see only that you are smiling

NOTE 1893

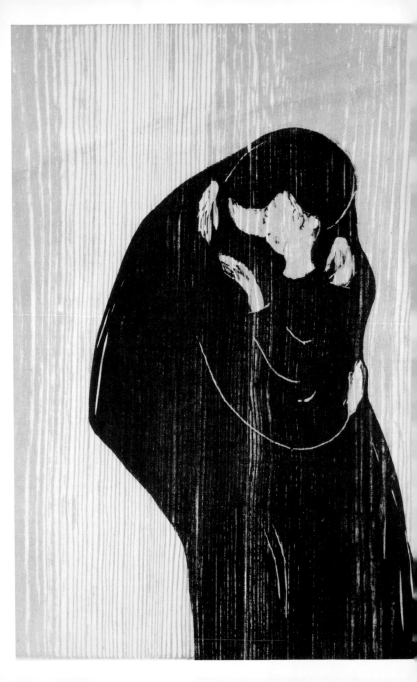

THE KISS

Two burning lips
against mine
Heaven and earth
vanished
And two black eyes
gazed into mine

SKETCHBOOK 1930–35

Here I learned the Power of two Eyes that grew
as large as Heavenly Globes in close Proximity –
which sent out Threads that – sneaked their way
into my Blood – my Heart.
– Here I learned the peculiar – Music – of the
Voice – which was now tender – now teasing
now inciting

SKETCHBOOK 1903–08

The old folks were right when they said that
love was a flame – for like the flame it leaves
behind a mere heap of ashes

SKETCHBOOK 1891–92

I stood before the Mystery of Woman –
– I gazed into an undreamt-of World –
My Curiosity – was awakened –
– What meaning did this Gaze have – what did
it show – this Gaze[,] that I did not know

SKETCHBOOK 1903–08

Human fates are like planets
Like a star that emerges from the dark – and
meets another star – shines for an instant before
disappearing again into the dark – in this way –
in this way a man and a woman meet –
Only a few meet in a single large blaze – where
they both can be fully united

Undated note

One Day I say to Miss L. what shall a poor
Man do who cannot experience true Love
– who cannot marry – first of all Marriage
impedes Art – and one who has already been
burned by Love cannot love anew

Sketchbook 1908

In good health
I came to you
like a ghost
I leave you

DRAFT OF A LETTER
TO TULLA LARSEN, 1899

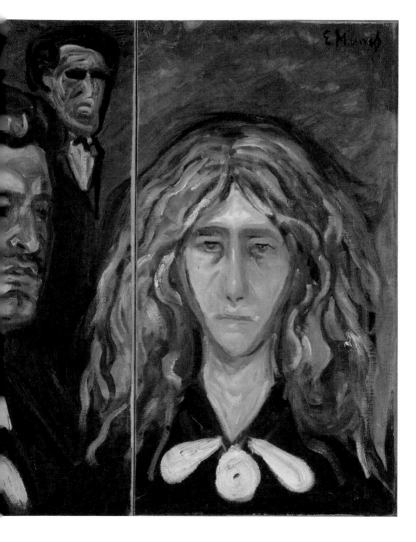

My dear Tulla! I have not written –
since ill as I have been the entire time
and in the most detestable of moods
I have not wanted to risk letting myself loose
in a letter in such a mood –
I am better now – but for how long?

DRAFT OF A LETTER TO TULLA LARSEN, 1899

I have a feeling that I am not the man who can
satisfy You in the long run …
I am basically a dreamer – who puts love in
second place – after my work

DRAFT OF A LETTER TO TULLA LARSEN, 1900

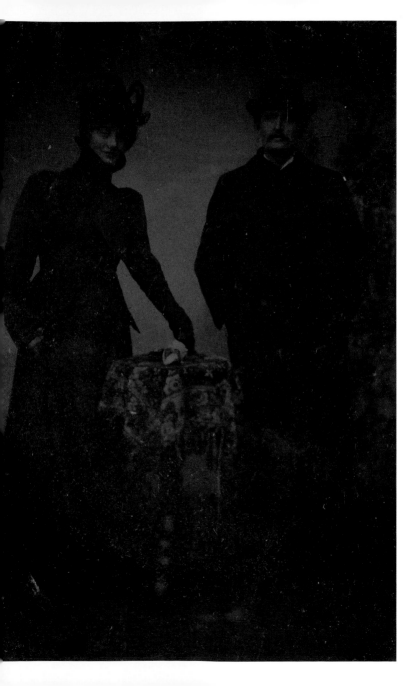

DA VI STOD MOD HVER-
ANDRE OG DINE ØINE
SA IND I MINE
ØINE DA FØLTE JEG
SOM USYNLIGE
TRAADE GIK FRA
DINE ØINE IND I
MINE ØINE OG
BANDT VORE HJER-
TER SAMMEN.

When we stood facing each
other and your eyes
gazed into my
eyes I felt as
though invisible
threads lead from
your eyes into
my eyes and
trussed our hearts
together

SKETCHBOOK 1930–35

And disaster came – because You only
considered Your own love – and Your own
desire – Your own will – My poor view of life
was thus forced to capitulate
I cannot reproach You for this – I can
admire Your strength as a woman –
and despise my weakness as a Man
But it is a disaster when a woman like You
meets a man like me
an encounter between two
such disparate world views

Draft of a letter to Tulla Larsen, 1900

my Misfortune lies in having met Women
with blond or fiery-red Wisps of Hair
on Heads with elongated skulls –
and Eyes like Blueberries on Pinheads
– Had I found my Soul's Reflection –
in two coal-black Eyes – what kind of Painter
would I have become then

LETTER TO SIGURD HØST, 1911

Your lips are like two ruby red snakes
and filled with blood like
the crimson fruit
– They separate as though in pain
A corpse's smile
For now the chain has been linked
which ties generation to generation

SKETCHBOOK 1930–35

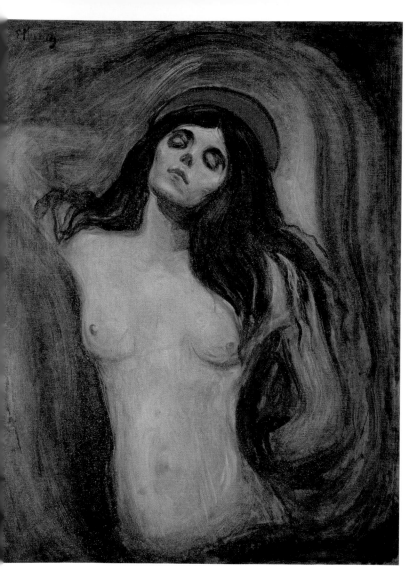

In the Evening I dreamt
that I kissed a Corpse and
jolted upright in Angst
– I had kissed the pallid Smiling lips
of a Corpse –
a cold clammy Kiss –
And it was Miss L.'s Face

SKETCHBOOK 1908

She rubbed me with her Hands
across my Brow –
What are You doing I asked?
Are You hypnotising me –
– Immediately after she stood at
the Door of the Studio –
Tall – a thin Face – and piercing Eyes –
surrounded by gold hair
like a Halo – A strange Smile –
through the tightly drawn Lips –
Something of a Medusa head
– An inexplicable feeling of Angst
came over me –
A Shudder –
Then she left – and I began
the Dance of Life

Sketchbook 1908

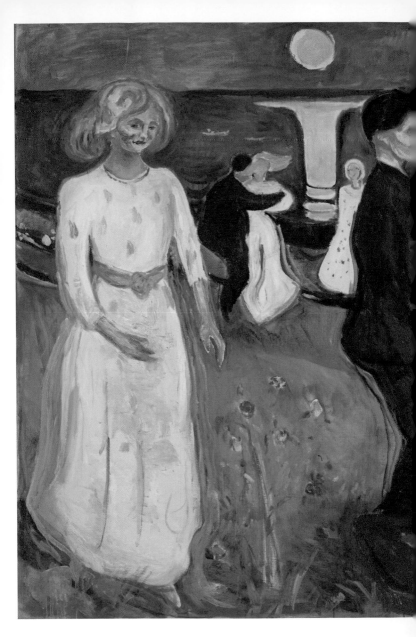

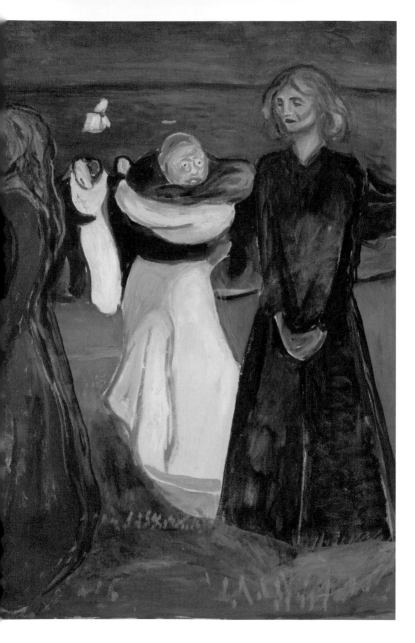

VIGELAND AND OTHER ARTISTS

When Vigeland shits a piece of clay
the state pays 10,000 kroner for it –
The State gives millions upon millions
to Vigeland's ideas [for the] Fountain –
[which was] my idea.

UNDATED SKETCHBOOK

It seems there is a difference between people –
Look at how everyone behaves
towards Vigeland –
All he has to do is spit
and it is set in gold

Undated sketchbook

When I modestly build wooden houses to carry
out my ideas in they say
What does he use these houses for?
For storing pictures for sale they say
He must be hanged –
He must be taxed on these pictures

Undated sketchbook

Henrik Sørensen uses speech as a force
to coerce people into carrying out his plans –
He uses the gaseous war of language to attack
while I use it in a defensive war –
He anesthetises his opponents with a storm
of words – which envelopes him in an
impenetrable haze of lyrical poisonous gas – of
miniscule gas bombs of spit, which explode in
his opponent's ears and eyes
anesthetise him confuse him until he
becomes a nearly lifeless mass. Then like the
viper he plants his fang filled with venom into
the lifeless prey – which he
can then devour whole

SKETCHBOOK 1927–34

Van Gogh during his short lifespan did not
allow his flame to extinguish – Fire and
passion were in his brush the few years that he
consumed himself for his art
I had thought and wished during my
longer lifespan and with more money at
my disposal, like him
not to allow my flame to extinguish and with
burning brush to paint until the very end

SKETCHBOOK 1927–34

When my lack of restraint acted up again it
affected one of the ladies
– In retaliation a campaign of lies was launched.
This resulted in my throwing Karsten out of my
house and I myself crushed the wrist of my left
hand – This hand was already impaired –
There were other fights and so I left
Aasgaardstrand

UNDATED DRAFT OF A LETTER TO JENS THIIS

I on my back – down on the ground –
Karsten in a white suit in front of me
also on his back – we both raise our
heads facing each other –
Now he is going to rush at me
I thought
– It's now or never
I shoved my heel into his eye
My left hand ached – was it broken?
Karsten stood up and staggered out
of the garden – in his white suit –
bloodstained – swollen eye

Note 1936–40

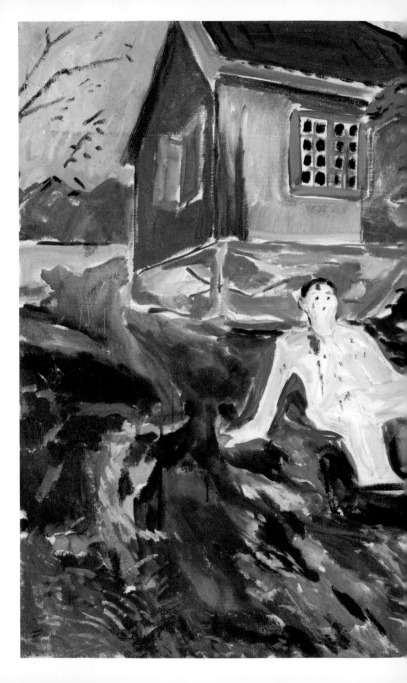

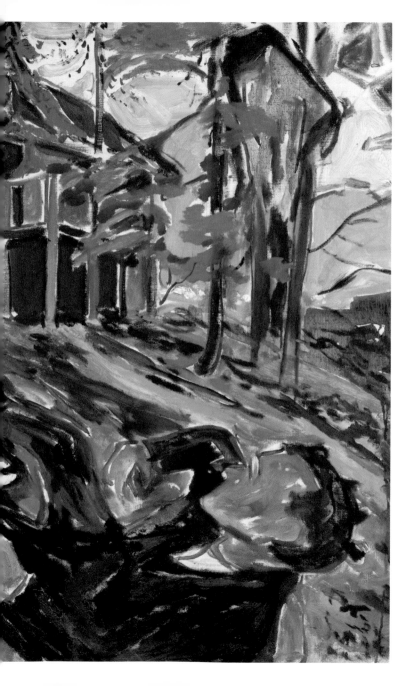

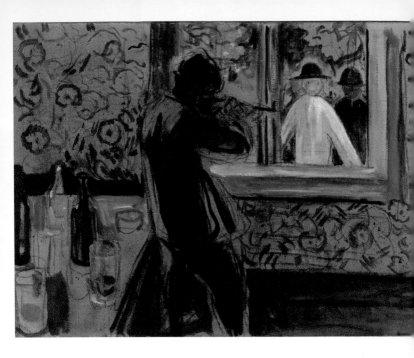

Müller positions himself in front of
Karsten and shoves him backwards
– They leave – Was it merely a threat?
But the hand on the trigger [is]
wild and senseless –
Would I have pulled the trigger
had he not left?

Note 1936–40

"Aftenposten" revelled in profanities
and vile remarks. –
This anti-art paper nevertheless fulfils
a kind of necessary demand. – A night soil
collector is also useful. – "Aftenposten" has
always had and has its Jonas Rask.[2] – These are
people who have dabbled a little with the brush
and have received mediocre marks
in Norwegian composition.

NOTE 1917–27

Professor Liebermann said of me: He is cunning
he pretends that he knows less than he does.
I responded: Liebermann pretends that he
knows more than he does. He is more cunning.

UNDATED NOTE

2 Jonas Christian Rasch (1834–1887), Norwegian lawyer. Art critic in *Aftenposten*
during the 1870s–80s and later in *Dagen* and *Dagbladet*. Often wrote under the
initials J.R.

I have donated my Strindberg
portrait to the National Museum in
Stockholm. I have the impression
though that it doesn't really arouse
any enthusiasm! As always when one
donates something. I was extremely
fond of it

LETTER TO JENS THIIS, 1934

P.S.
Frankly I cannot but have the impression that
the Strindberg portrait has arrived like a bomb
in Stockholm
They must think that it was more than tactless –
For the Swedes always paint Strindberg
with a stylised ideal head

DRAFT OF A LETTER TO JENS THIIS, 1934

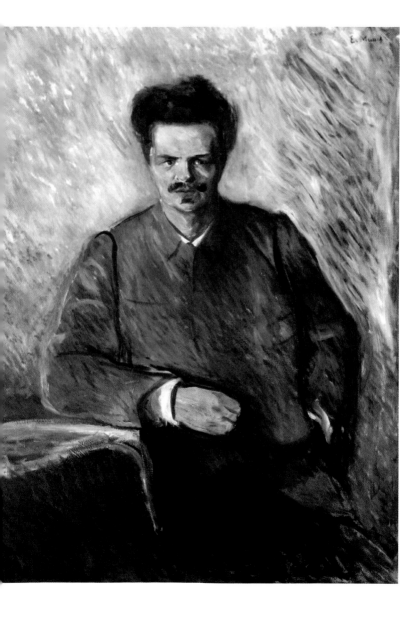

WORLDVIEWS

I saw all the people
behind their masks –
smiling, phlegmatic –
subdued faces –
I saw through them
and there was suffering –
in them all –
pale corpses – who restlessly
nervously – scurried about –
along a tortuous road whose end
was the grave

NOTE 1896

What is the soul when a medication
can tear me out of the predatory bird's claws
and anxiety's raving mind and
bring me peace – and a different
view of life?

SKETCHBOOK 1927–34

NOTHING IS SMALL, NOTHING IS GREAT

SKETCHBOOK 1930–35

The priest states on the radio:
Christ says God is in me
I am in God – the Father is in me
– I in the father

Isn't that the same as what
anyone might say:
I am in God. God is in all things
– I am in the world – the world is in me

SKETCHBOOK 1927–34

Do not tread on my spiritual corns

Sketchbook 1927–34

I tumble about amidst this teeming life – But I
must return to the road along the precipice – It
is my road the one I must follow – I waver
I wish to plunge downward – Once again
towards life and human beings – But I must
return to the road along the precipice – For it is
my road – until I plunge into the depths

Sketchbook 1927–34

If one is treated like a Dog one becomes a Dog

Sketchbook 1908

We despise Humans but we are together with
them – we must be together with – them – for
we have use for them – it's extremely irritating

Undated note

– From Birth – the Angels of Angst
– of Sorrow – the Angels of Death stood by
my Side followed me outdoors when I played
– followed me under the Spring Sun – during
Summer's Splendour
– They stood by my Side in the Evening when
I closed my Eyes – and threatened me with
Death Hell and eternal Damnation –
And it often happened that I woke up
in the Night – and stared in wild Fear
out into the Room
Am I in Hell –

UNDATED SKETCHBOOK

God, if only someone wanted to die for me –
even if he died of Boredom

NOTE 1903–05

Jeg gec gik langs veien. med to venner. Saa. gik soeen ned. Him- len blev pludselig blod og jeg tøite det store skric i naturen

I was walking along the road
with two friends when
the sun went down. The sky
suddenly turned
to blood and I felt
a great scream
in nature

SKETCHBOOK 1930–35

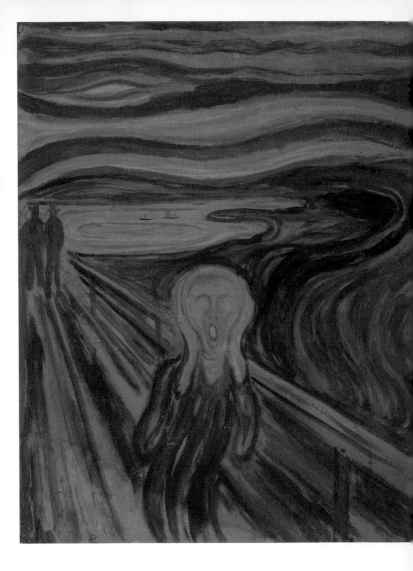

I walked along a road one evening –
on one side the town
and the fjord lay beneath me.
I was weary and sick – I stood looking
out over the fjord – the sun was setting
– the clouds turned the colour red
– like blood –
I felt as though a scream passed
through nature –
I thought I heard a scream –
I painted this picture –
painted the clouds like real blood –
the Colours screamed –
It became the picture *Scream*
in the frieze of life.

Undated, printed booklet

I have already for a lifetime talked to friends
about and likewise noted in my diaries that
everything is in motion that even in the stone
there is life

…

I have for a long time claimed that the earth is
also a living being

…

We see the round shapes of the planets only
with our eyes.
– But the auras?
Everything is round –
Human Beings with their auras and all life

Note 1927–34

How fortunate you are – you have modern parents – who have not taught you about the bible – who did not let it seep into your blood – oh these lovely dreams – the ones about joy and life after death

NOTE 1890

MONEY

———

I have never in my life thought of
wealth when I was working –
It wasn't until my pictures became
valuable that people began to show
an interest in them –
Up until I was 45 years old people
shouted "bloody hell" at the very
sight of them

UNDATED SKETCHBOOK

– Why don't You paint small pictures for sale
like others said my milkman
Keep to your cowshed I said
That's something You understand

NOTE 1927–33

I am not king Midas and everything I touch
does not turn to gold –
It's true that I have for many years worked on
an autobiography and made notes –
I would probably be able to earn money on
them if I completed and published them –
But one cannot tax these notes –
Nor the many good ideas I have in my head –
They cannot be taxed

UNDATED LETTER TIL JOHANNES ROEDE

I finally succeeded and the money arrived after
I lived like a vagabond until the age of 45 –
Had I worked in order to sell – I would have
ended up like others
Shitty art and shitty sales

Undated sketchbook

Incidently it is not the amount of taxes itself
that has caused me damage – It is the immense
disturbance to my work when twice a year one
has to fill in a tax return in such detail –
Once in January and once in autumn when the
tax authorities tell me that I have calculated
incorrectly

Undated letter to Johannes Roede

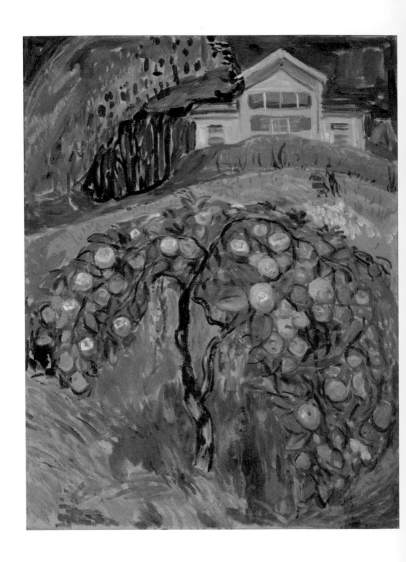

What if Edison and Marconi had lived
in Vestre Aker
They would both have had countless
prospects for inventions that had not
been put into use –
The wise men of Vestre Aker would
have surely decided that they were
worth millions and taxed them
accordingly

Undated sketchbook

Here I have for 30 years painted
the frieze of life
I have not earned more than to be able to help
my family and attempt to execute my ideas
and try my hand at wall paintings –
I myself live rather a Spartan life

DRAFT OF A LETTER TO JOHAN LANGAARD, 1934

In the southern open-air studio are unfinished
drafts for the so-called city hall decoration
How can anyone expect me to bring them
to completion when for years I have been
interrupted in every possible way here in Vestre
Aker and not least by the tax authorities –
Does one expect that I should be taxed for these
before I manage to sell them
Does one not only tax the cow and the milk
but also the embryo calf in its abdomen

UNDATED SKETCHBOOK

DEATH

WE DO NOT DIE
THE WORLD DIES FROM US

Sketchbook 1930–35

Those at home, my aunt my brother
and my sisters, believe that death is
merely sleep – that my father
can see and hear –
That he roams about in glory and joy
up there. That they will meet him again
some day –
I cannot do otherwise than to release
my grief into the day that dawns and
the day that wanes
I sit alone with millions of memories
… they are a million daggers that tear
at my heart – and the wounds lie open

NOTE 1899

We have experienced death at birth
— What awaits us is the strangest
experience of all: The true birth which
is called death — to be born into what?

Sketchbook 1927–34

Then why does one hang Poison Murderesses
– or punish a Maid who has stolen –
They are perhaps better Human Beings than the
clandestine Criminals

SKETCHBOOK 1908

The dead
How hopeless to attempt to [repair] what was
torn asunder in life –
It is like trying to put together a broken glass.

SKETCHBOOK 1927–34

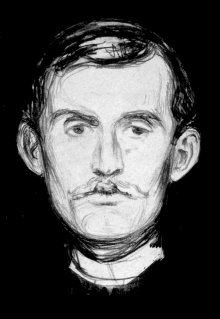

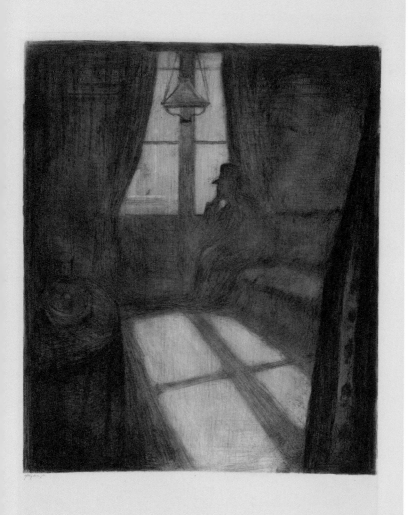

EDVARD MUNCH
(1863–1944)

Edvard Munch was one of Modernism's most significant artists. He was active throughout more than sixty years; from the time he made his debut in the 1880s, right up to his death in 1944. Munch stood out as a Symbolist in the 1890s, and became a pioneer of Expressionist art from the beginning of the 20th century onward. His tenacious experimentation with motifs and different techniques has given him a unique position in Norwegian and international art history.

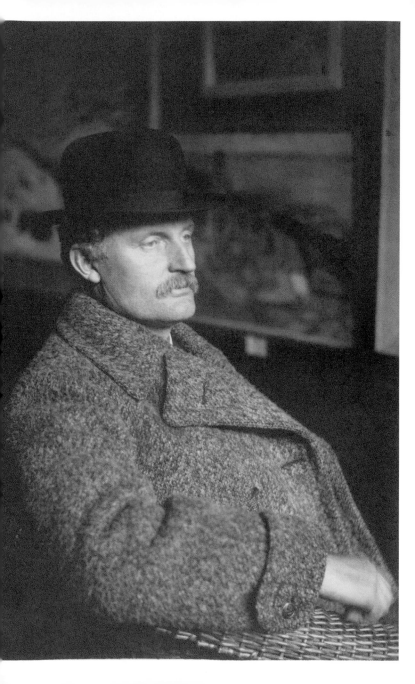

MUNCH'S TEXTS

———

Edvard Munch wrote throughout his
entire life: school papers, diary entries,
prose poetry, literary sketches, drafts of
plays, apologias, travel letters, commentaries
in the press, contracts, applications, and of
course letters. The letters come in the many
forms used during the times he lived in;
short missives delivered by messenger boys,
telegrams, postcards, long private letters, orders
and receipts. The other texts are written in a
range of literary genres, or as reflections on
art and the work of an artist, but also ordinary
texts which everyone writes in the course of a

lifetime: lists of things to remember, shopping lists and order forms for purchasing wares.

It was through the written word that Munch kept in touch with family and friends, and he also administered his artistic career as a self-employed professional through correspondence with assistants, patrons, collectors, art dealers, printers, newspaper and magazine editors, writers, art historians, exhibition organisers, gallery owners, shipping companies, and more.

In his literary writings Munch experimented with lyrical prose, prose poems, fragments, short stories and drama. His themes revolve around childhood memories, amorous situations and mockery of his "enemies"; motifs that he also treated in his art. The material stems of course not only from his private sphere, but also from the cultural sphere that he belonged to. Munch's treatment of the human condition, of existential states, is just as much

marked by cultural as by private conditions, and this is what makes his appeal so great.

That Munch had plans to publish the texts is apparent in many contexts, among others in his will. It is apparent that he understood that the texts had both quality and potential, and that the interest his life and work aroused in the public would continue after his death.

In the Munch Museum's collection today there are more than 12,000 manuscript pages from Munch's hand. All of his texts are in the process of being published at www.emunch.no. A portion of them has been translated into English.

WORKS OF ART AND
PHOTOGRAPHS

———

P. 6 *Self-portrait*, 1882. Oil on paper mounted on cardboard. Munchmuseet

P. 14–15 *Elm Forest in Spring*, ca. 1923. Oil on canvas. Munchmuseet

P. 20 *Vampire in the Forest*, 1916–18. Oil on canvas. Munchmuseet

P. 25 *Self-portrait in Hell*, 1903. Oil on canvas. Munchmuseet

P. 28 *Blossom of Pain,* 1898. Woodcut. Munchmuseet

P. 32–33 *Towards the Forest I*, 1897. Woodcut. Munchmuseet

P. 34–35 Edvard Munch at Ekely, 1943.
 Photo: Ragnvald Væring © O. Væring Eftf.

P. 44–45 *Henrik Ibsen at the Grand Café*, 1902. Lithograph. Munchmuseet

P. 48–49 Edvard Munch by the easel in Åsgårdstrand, 1889. Photo: Torkildsen

P. 55 *The House by the Fjord,* 1902–05. Oil on cardboard. Private Collection

P. 57 *Kristiania Bohemians*, 1907? Oil on canvas. Munchmuseet

P. 58 *The Girls on the Bridge*, 1927. Oil on canvas. Munchmuseet

P. 60 *Spring in Kragerø*, 1909. Oil on canvas. Munchmuseet

P. 64–65 Edvard Munch in the open-air studio at Ekely, ca. 1933.
 Photo: Ragnvald Væring © O. Væring Eftf.

P. 70 *Self-portrait at the Wedding Table,* 1925–26. Oil on canvas. Munchmuseet

P. 74–75 *At the Roulette Table in Monte Carlo*, 1892. Oil on canvas.
 Munchmuseet

P. 76–77 Edvard Munch in the studio at Skrubben in Kragerø, 1909–10.
 Photographic self-portrait. Munchmuseet

P. 82 *Vision*, 1892. Oil on canvas. Munchmuseet

P. 84 *Self-portrait in Front of the House Wall*, 1926. Oil on canvas.
 Munchmuseet

P. 86–87 Edvard Munch in the kennel at Ekely, 1932–33. Photo: Inger Munch

P. 91 *The Voice*, 1893. Pencil and crayon. Munchmuseet

P. 92–93 *The Kiss IV*, 1902. Woodcut. Munchmuseet

P. 96–97 *Self-portrait against a Green Background / Caricature Portrait of Tulla Larsen*, 1905. Oil on canvas. Munchmuseet

P. 99 Tulla Larsen and Edvard Munch, 1899. Ferrotype. Unknown photographer

P. 100 From Edvard Munch's sketchbook MM T 2547, 1930–35. Munchmuseet

P. 105 *Madonna*, 1894. Oil on canvas. Munchmuseet

P. 108–109 *The Dance of Life*, 1925. Oil on canvas. Munchmuseet

P. 110–111 Edvard Munch on the beach in Warnemünde with brush and palette, 1907. Photographic self-portrait. Munchmuseet

P. 118–119 *The Fight*, 1932. Oil on canvas. Munchmuseet

P. 120 *Uninvited Guests*, 1932–35. Oil on canvas. Munchmuseet

P. 123 *August Strindberg*, 1892. Oil on canvas. Moderna Museet, Stockholm

P. 124–125 Edvard Munch at Skrubben in Kragerø with a draft for the national monument, 1910. Photographic self-portrait. Munchmuseet

P. 131 From Edvard Munch's sketchbook MM T 2547, 1930–35. Munchmuseet

P. 132 *The Scream*, 1910? Tempera and oil on unprimed canvas. Munchmuseet

P. 136–137 Edvard Munch, nude, in the garden in Åsgårdstrand, ca. 1904. Photographic self-portrait. Munchmuseet

P. 142 *Apple Tree in the Garden*, 1932–42. Oil on canvas. Munchmuseet

P. 146–147 Edvard Munch at Ekely, 1930. Photographic self-portrait. Munchmuseet

P. 151 *Moonlight. Night in Saint-Cloud*, 1895. Etching. Munchmuseet

P. 152 *Self-portrait,* 1895. Lithograph. Munchmuseet

P. 156–157 Edvard Munch lying in repose at Ekely in January 1944. Photo: Inger Munch

P. 159 Edvard Munch at Kunstnerforbundet in Kristiania (Oslo), 1912. Photo: Anders B. Wilse © Norsk Folkemuseum

P. 160 From letter MM N 3337 to Ludvig Ravensberg, 1906. Munchmuseet